ANONYMOUS

ANONYMOUS

SCOTT JACOBS

ANONYMOUS

iUniverse books may be ordered through booksellers or by contacting:

iUniverse
1663 Liberty Drive
Bloomington, IN 47403
www.iuniverse.com
1-800-Authors (1-800-288-4677)

Because of the dynamic nature of the Internet, any web addresses or links contained in this book may have changed since publication and may no longer be valid. The views expressed in this work are solely those of the author and do not necessarily reflect the views of the publisher, and the publisher hereby disclaims any responsibility for them.

Any people depicted in stock imagery provided by Getty Images are models, and such images are being used for illustrative purposes only.
Certain stock imagery © Getty Images.

ISBN: 978-1-5320-7196-6 (sc)
ISBN: 978-1-5320-7197-3 (hc)
ISBN: 978-1-5320-7198-0 (e)

Library of Congress Control Number: 2019906730

Print information available on the last page.

iUniverse rev. date: 07/08/2019

To my aunt Karen, whom I miss deeply.
Her loss is the night permanently absent of stars. I miss her glow.
I love you, Aunt Karen.

ACKNOWLEDGMENTS

I want to thank California for letting me stare out at the Pacific and be an introspective twenty-year-old.

Thank you, Paris, for being my muse.

Thank you. Hieronymus Bosch, for *The Garden of Earthly Delights*.

Thank you Susan Sontag; I did not know you in this life however you were a gem and introduced me to the intensity of the intellectual.

Thank you, Handel; *Water Music* landed in my ears in high school, and for the first time I recognized myself in referring to something as "beautiful."

Thank you to my dad for the typewriter he gave me when I was thirteen. I understood that it wasn't just a gift—he saw me, he really saw me.

Thank you to my mom for letting me color outside the lines.

Thank you, Debbie Day, my sixth-grade guidance counselor. A few days before her retirement, she asked that I pay a visit to her office. She handed me a book by Brenda Ueland titled *If You Want to Write*. On the first page she wrote me a note. Some things are meant to remain private, and this note is one such thing. However, my heart and spirit will always admire the sentiment of that note and the gravity of the influence it has had on my life. I wish I could hug her and say thank you.

Jose: our friendship came about by happenstance and exists because life is beautiful.

John: we have traveled through life together. I recall our very first conversation—it was about Russian literature. From that night on our friendship took flight.

Douglas: your presence in my life is a gift. Thank you for being my sounding board and for our lunches at Baccarat—where else can you get such a great bite of food? You define the standard of decency and make me feel safe. I love you, Douglas, and all that you are.

Abby is my dog. No words can land on the page that would define the love I have for her.

Thank you, Manhattan. This book exists in part because you're in my life.

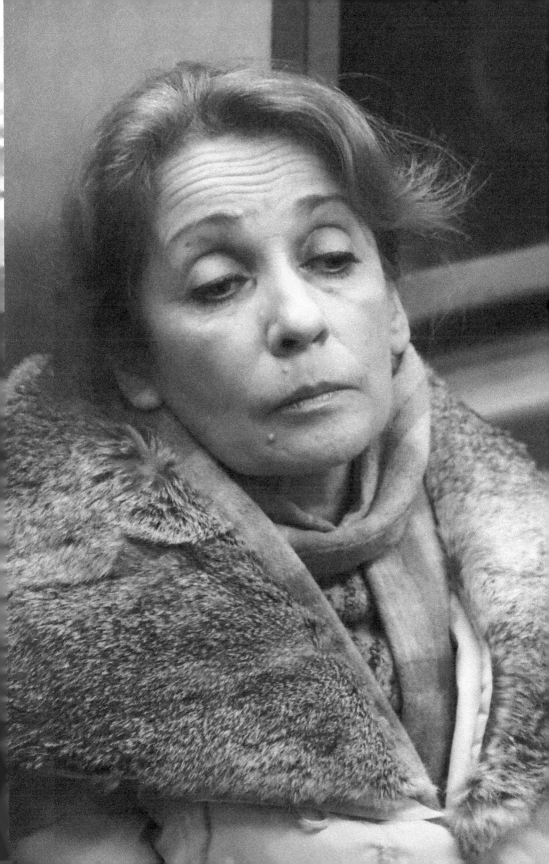

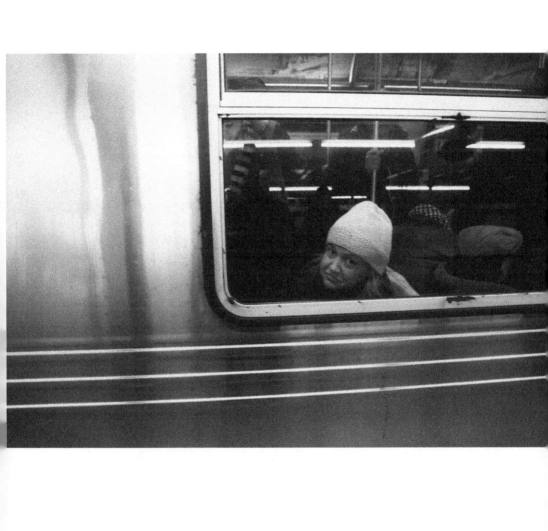

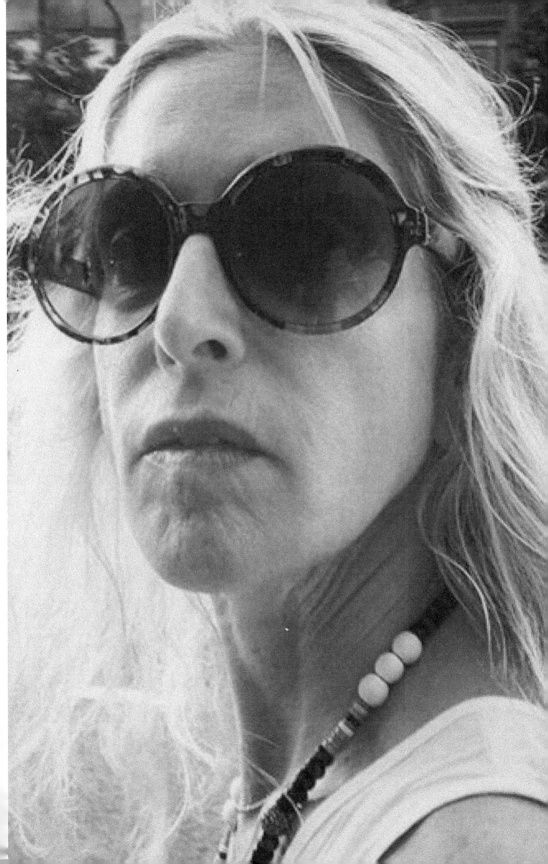

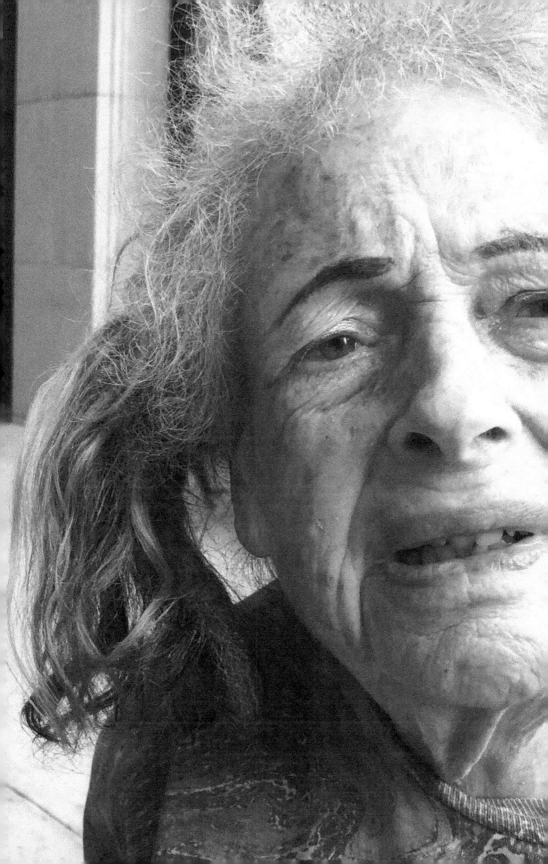

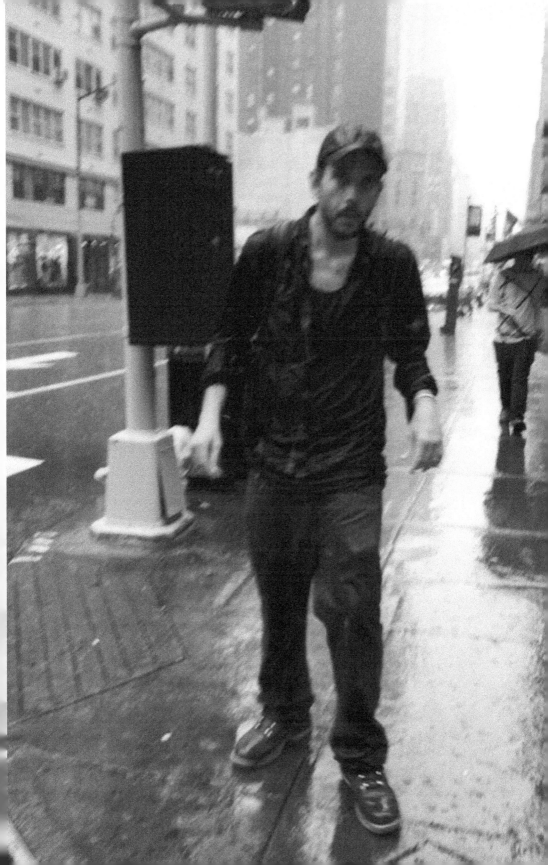

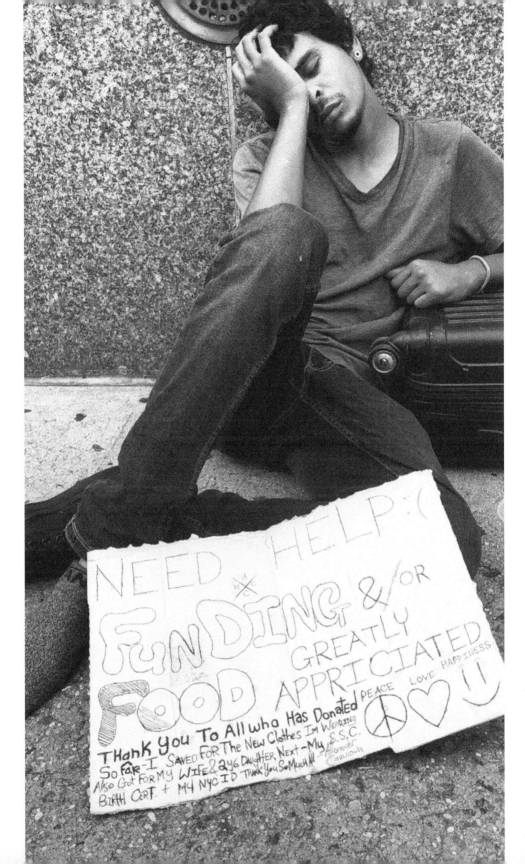

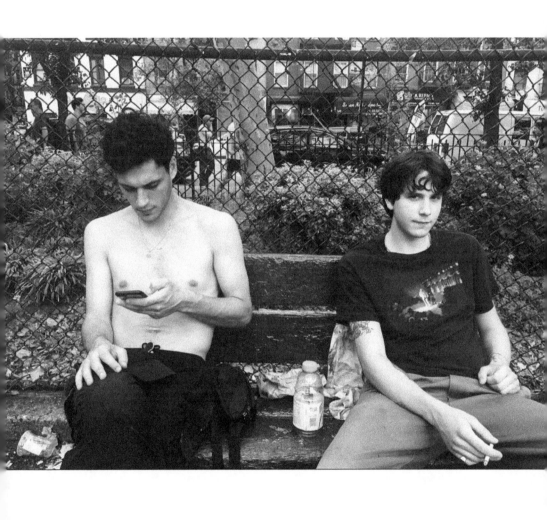

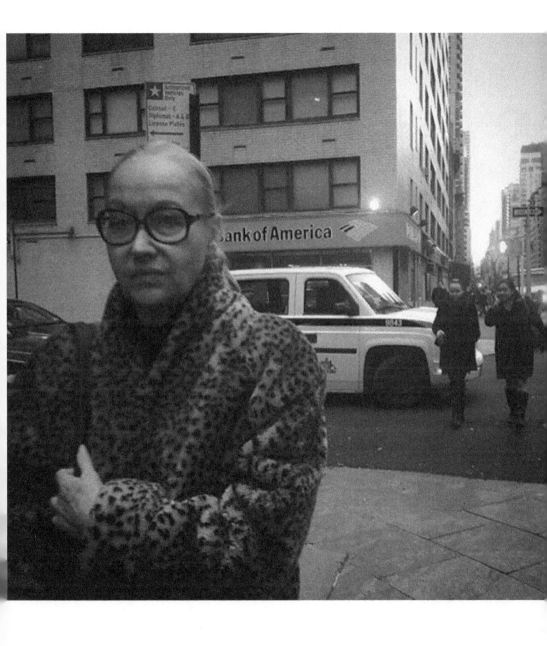

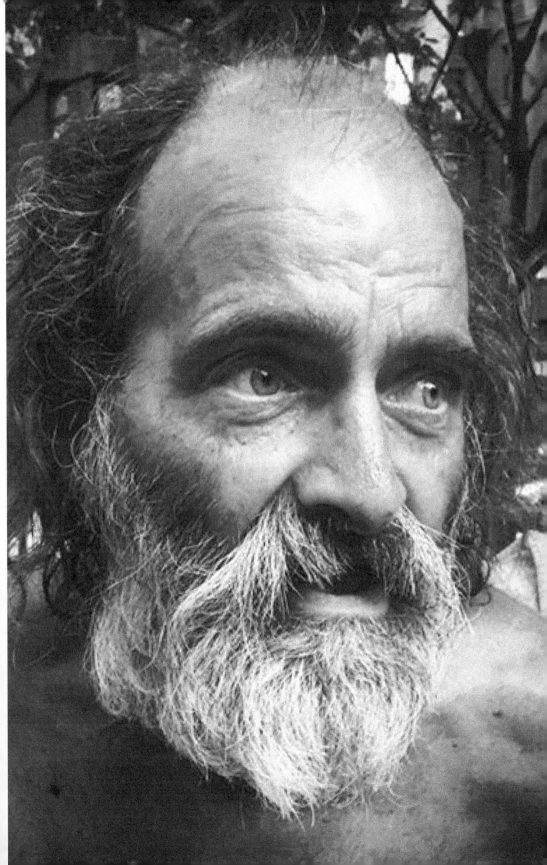

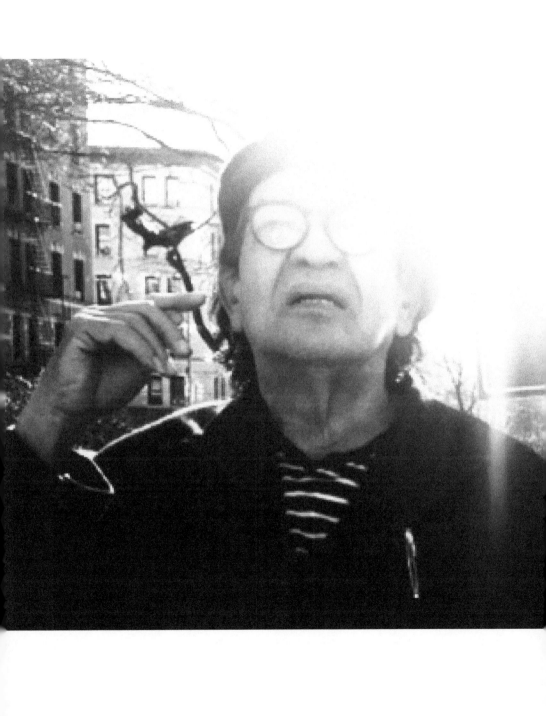

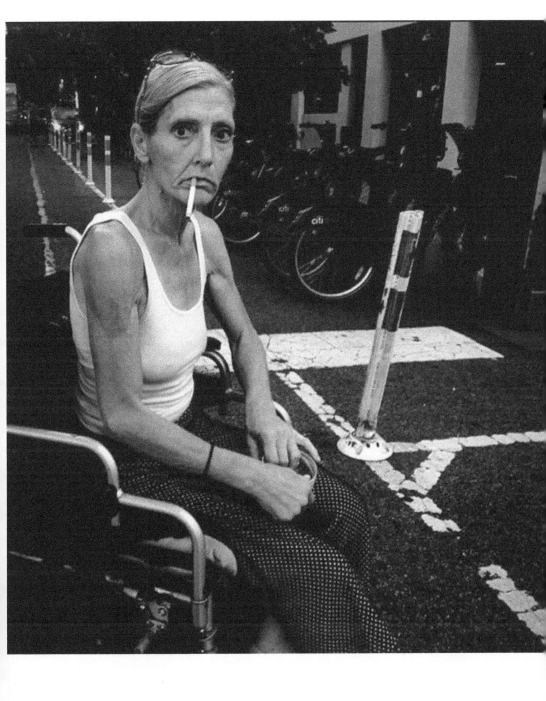

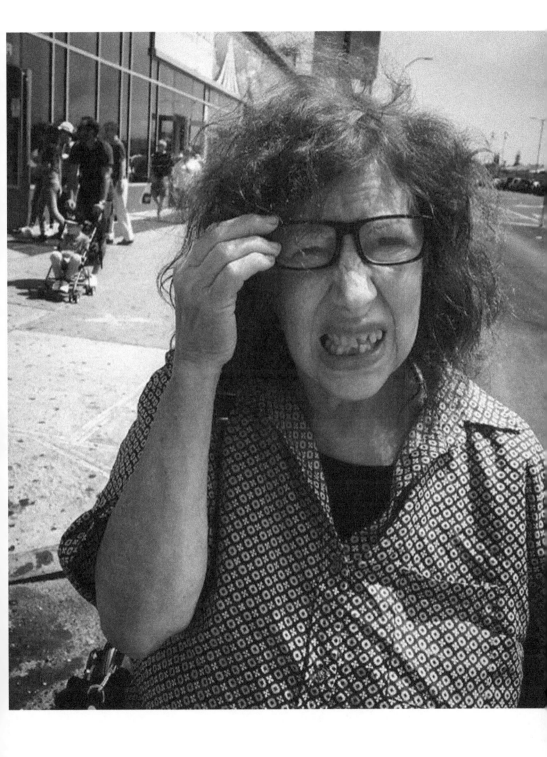

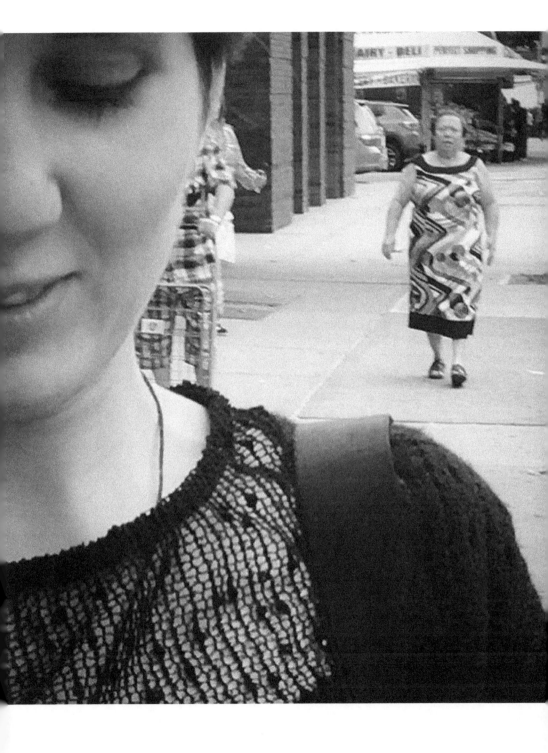

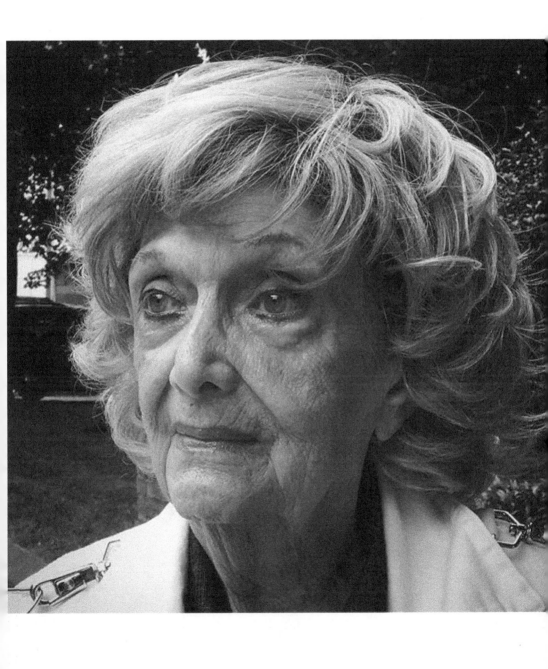

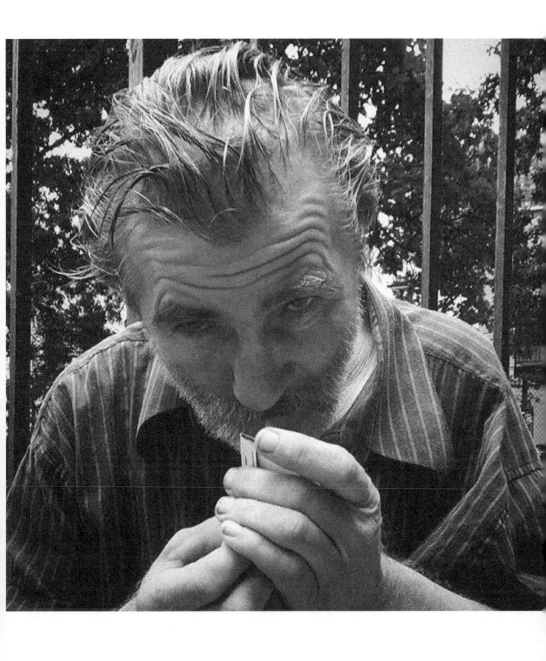

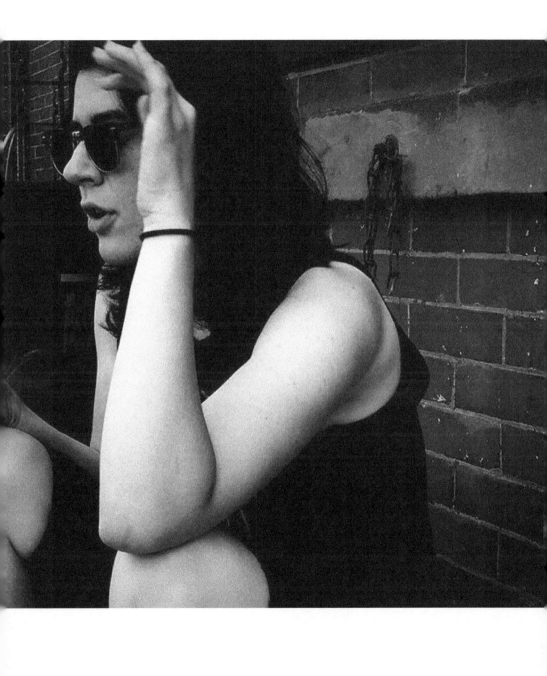

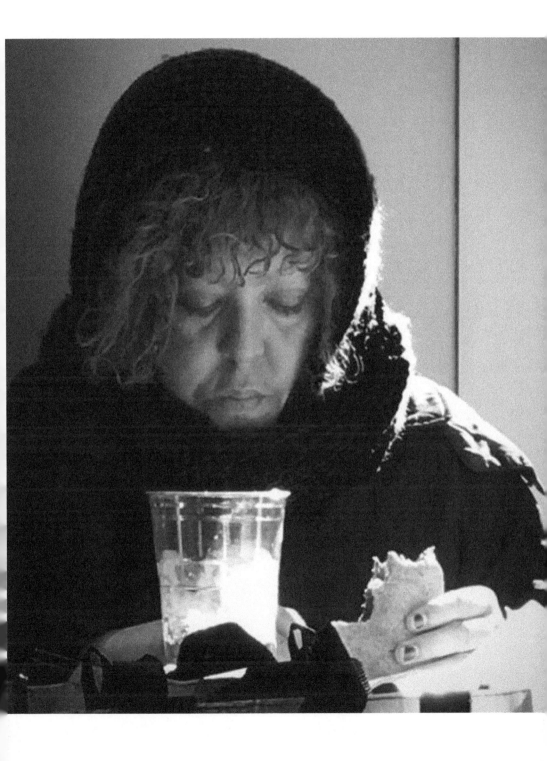

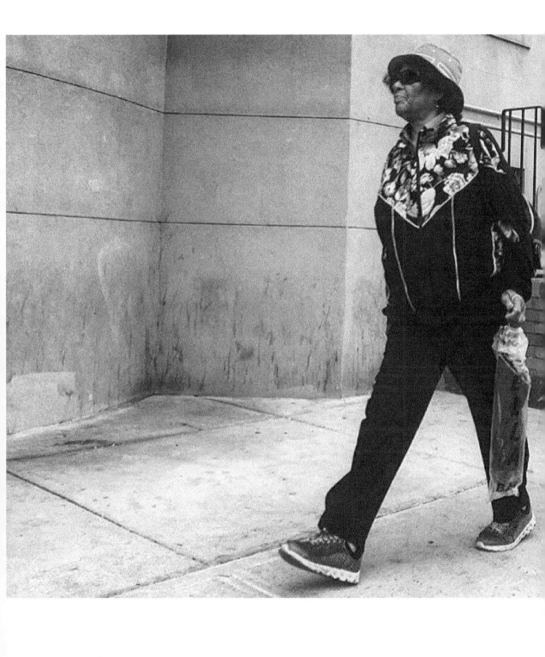

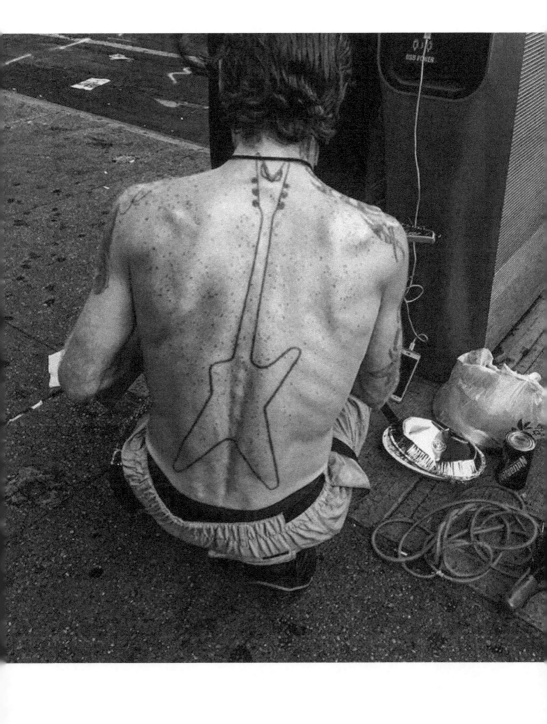

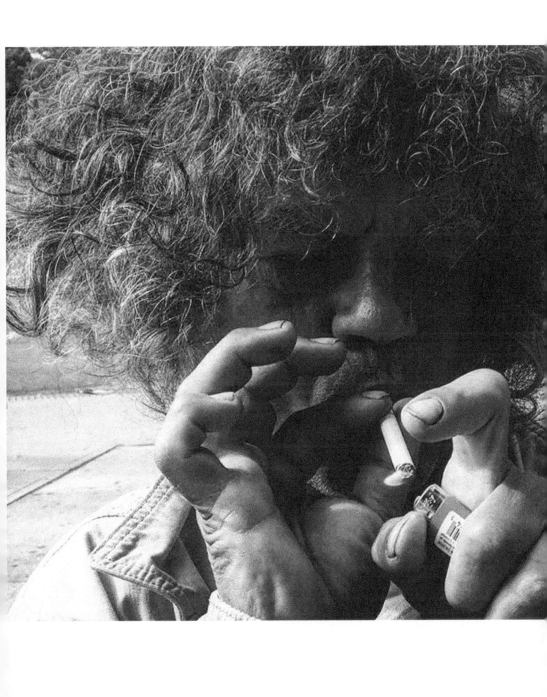

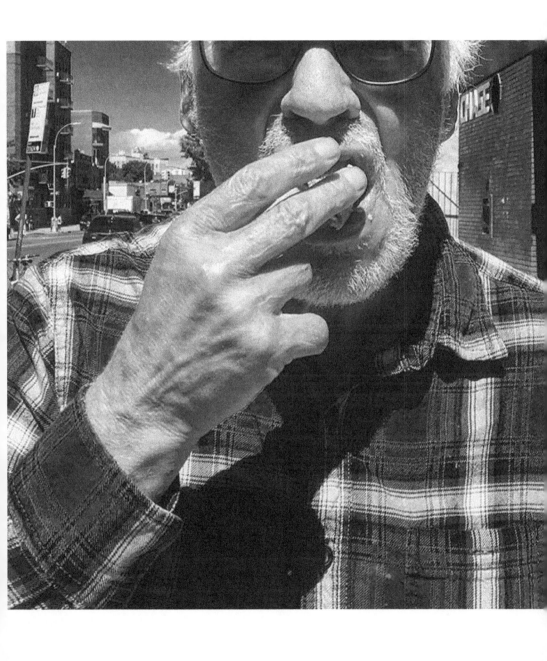

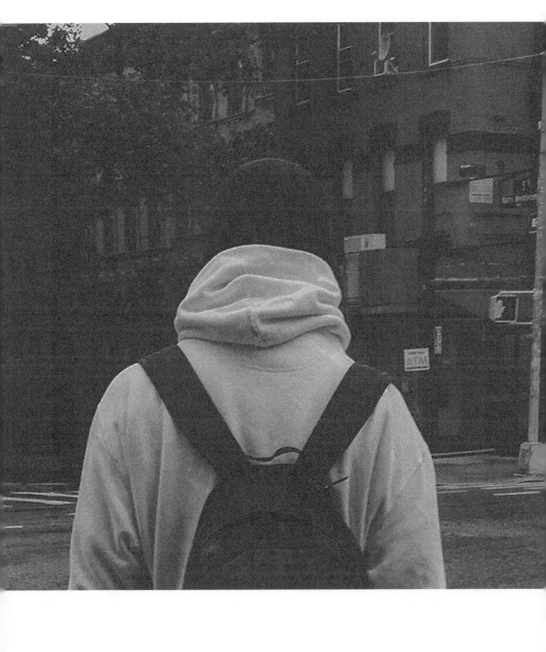

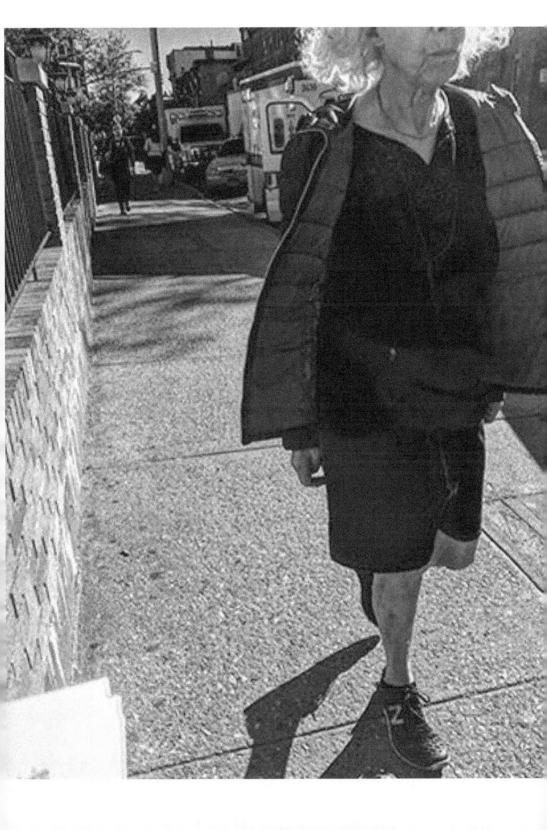

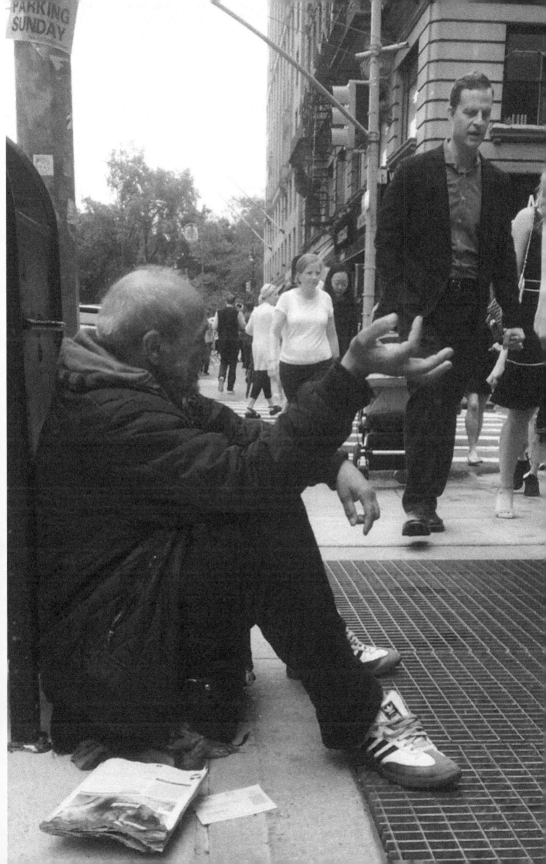

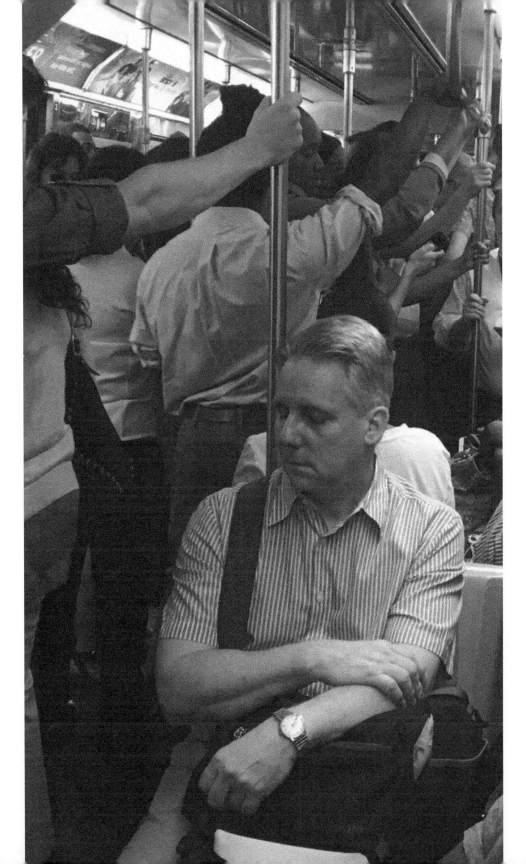

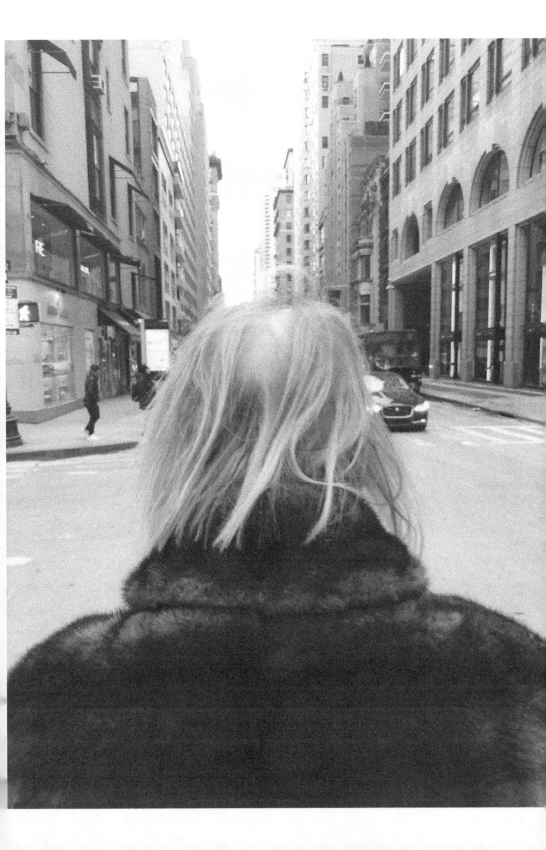

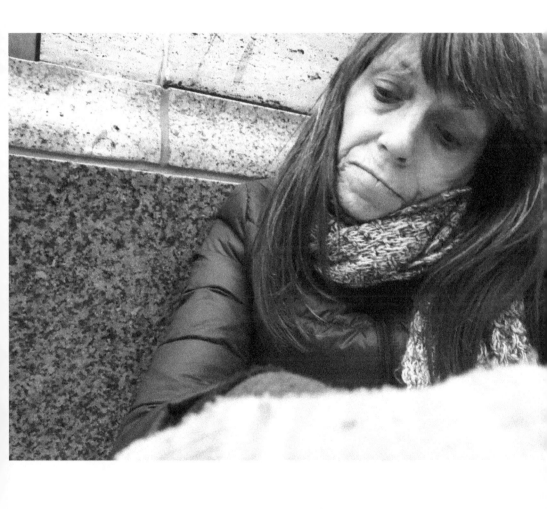

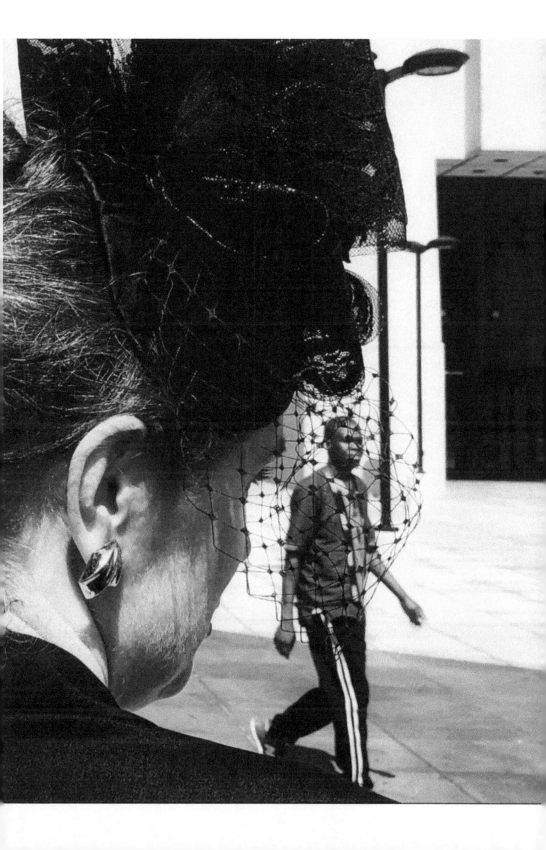

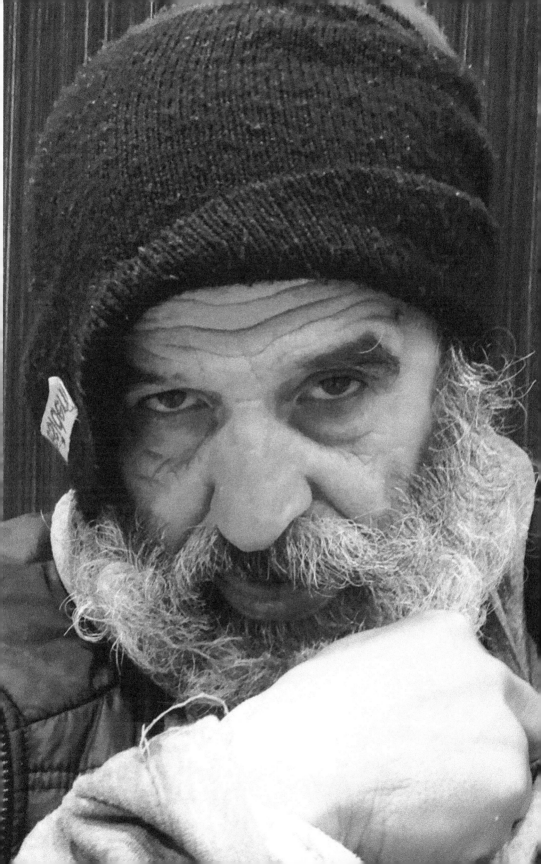

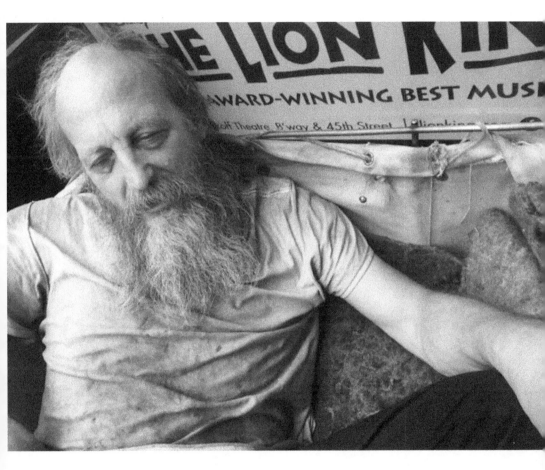

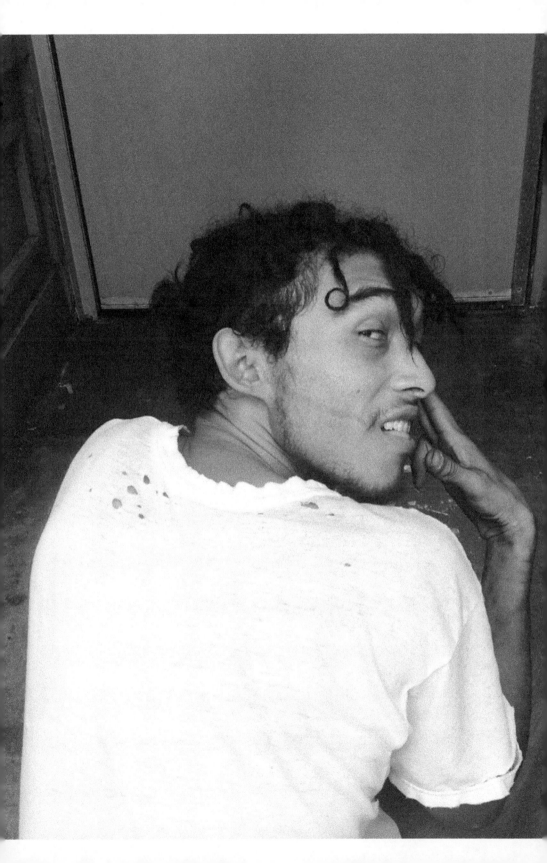

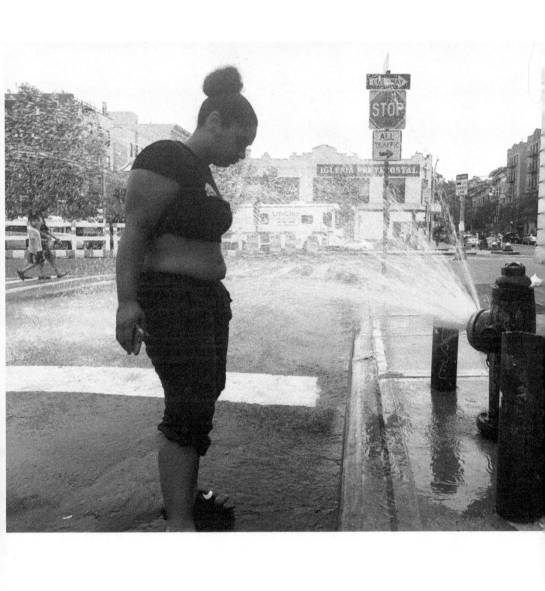

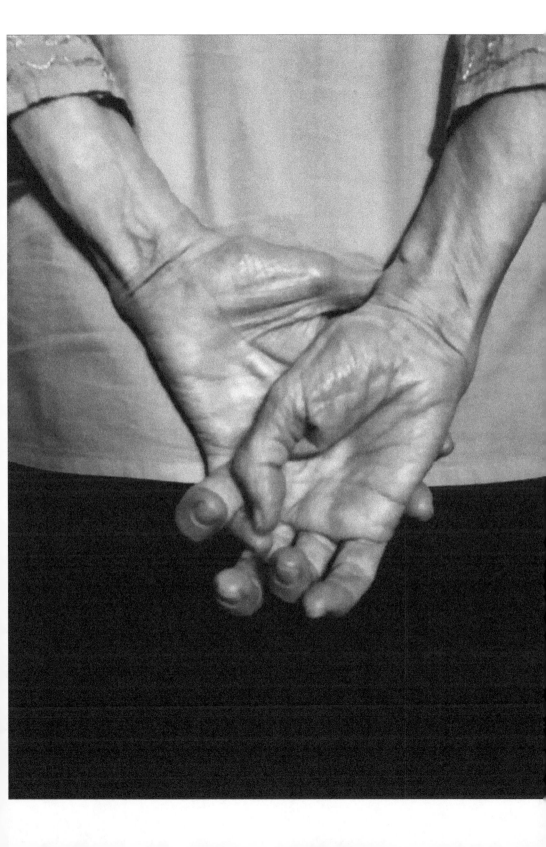

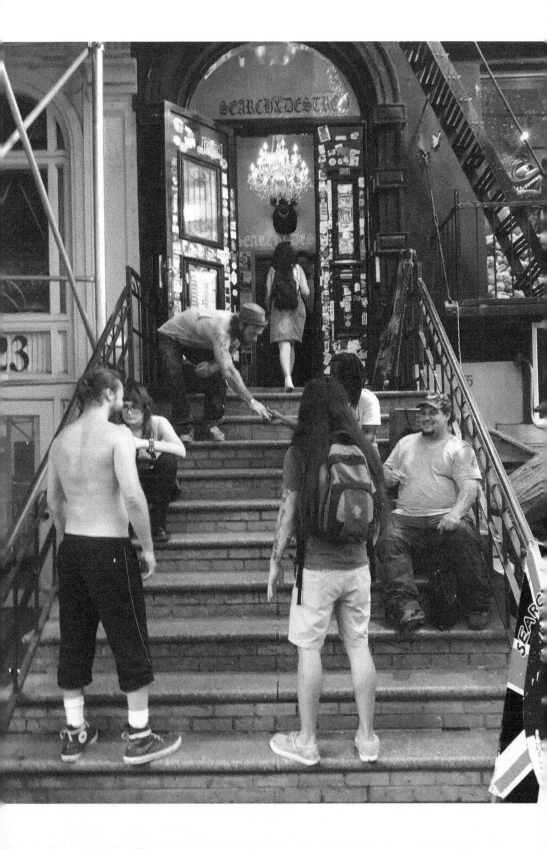

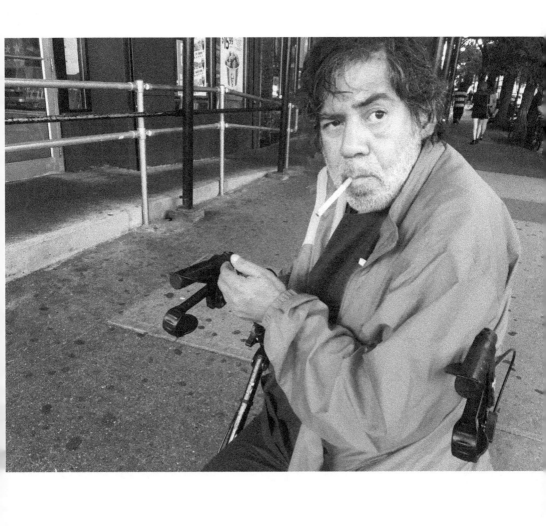

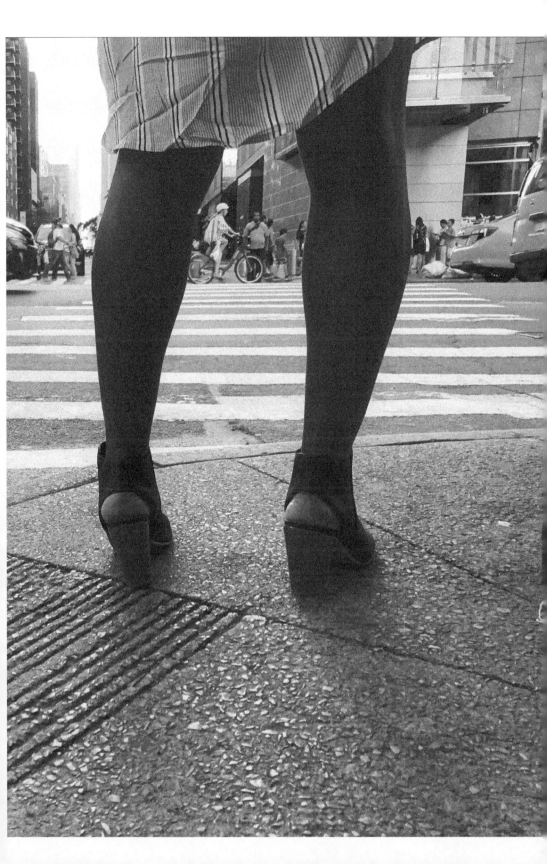

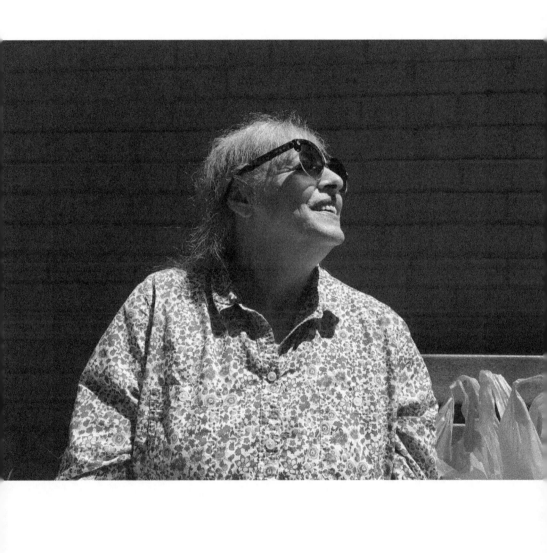

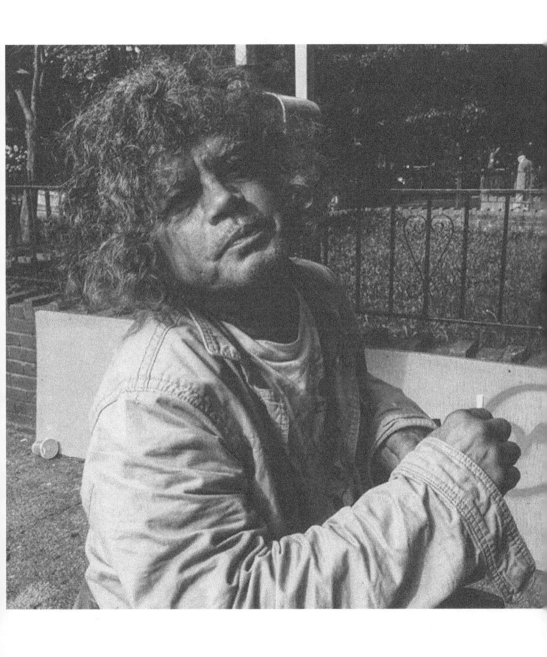

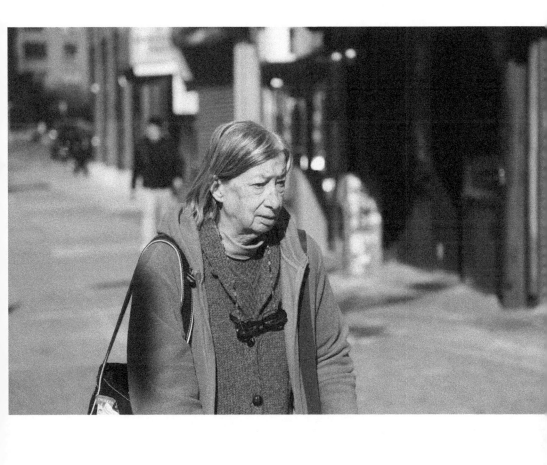

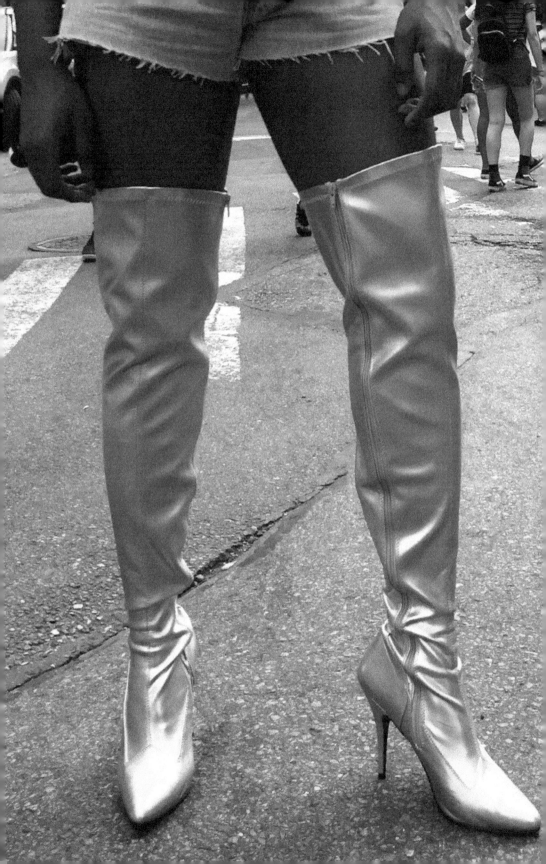

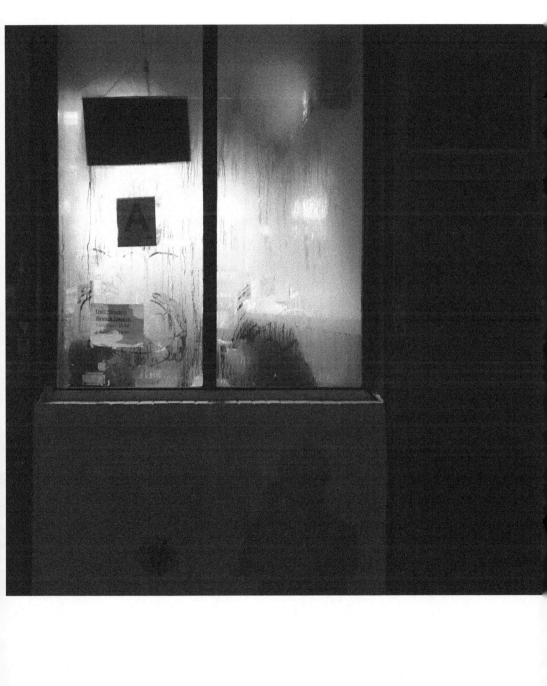

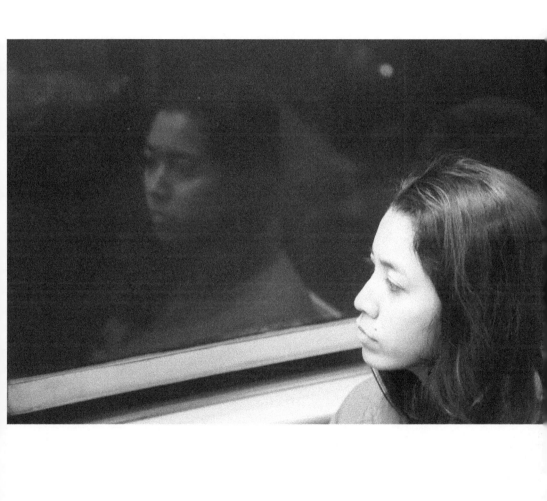

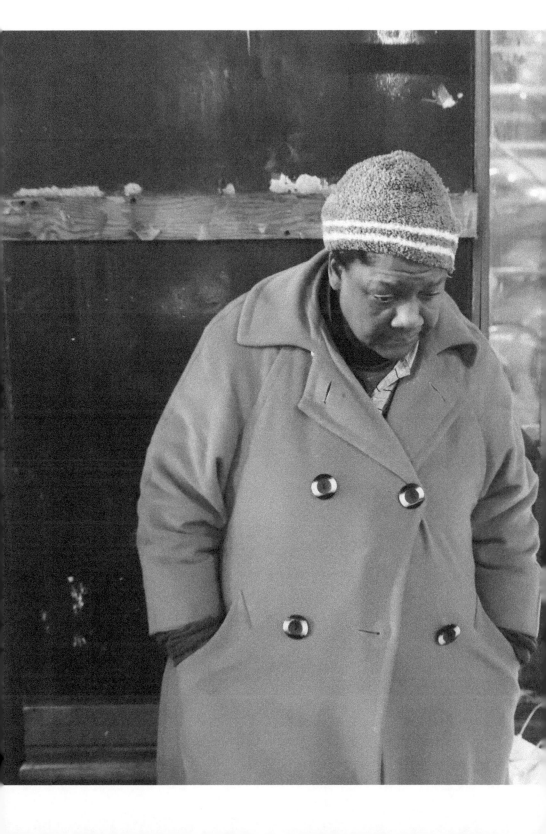

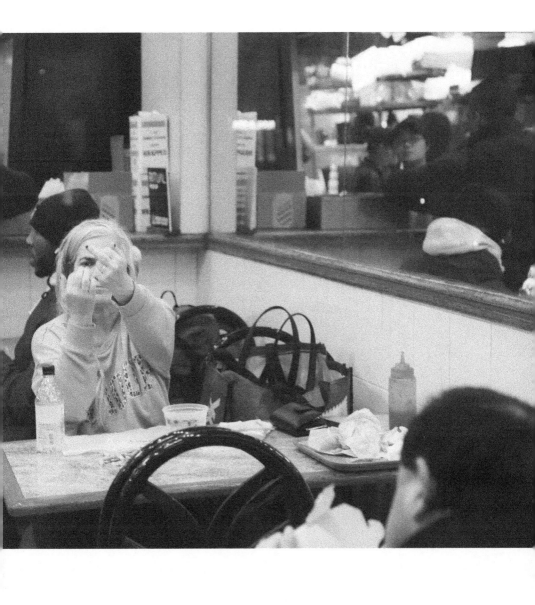

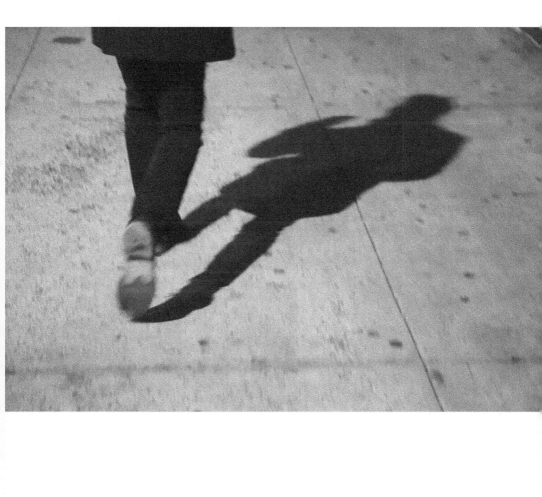

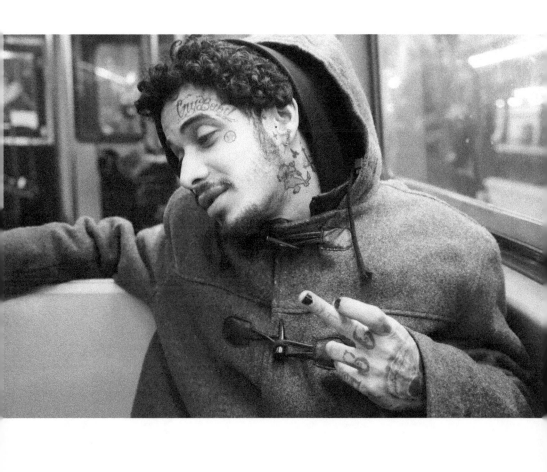

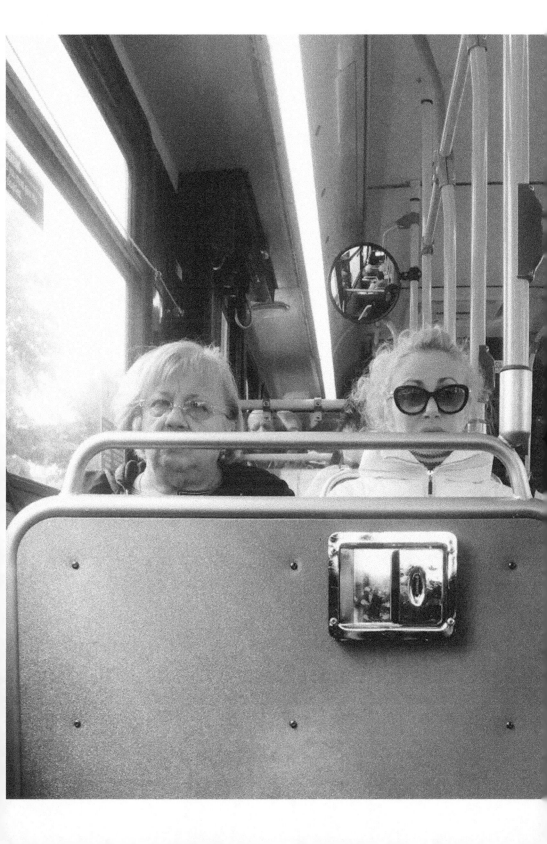

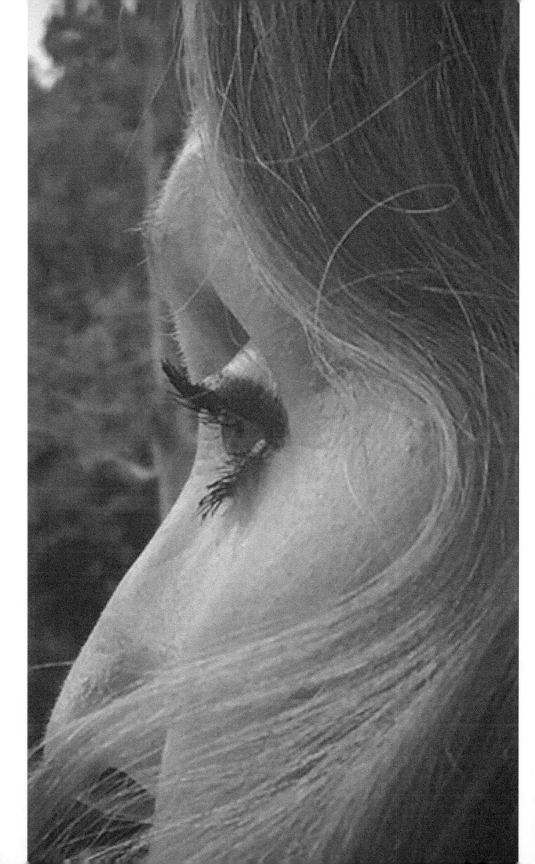

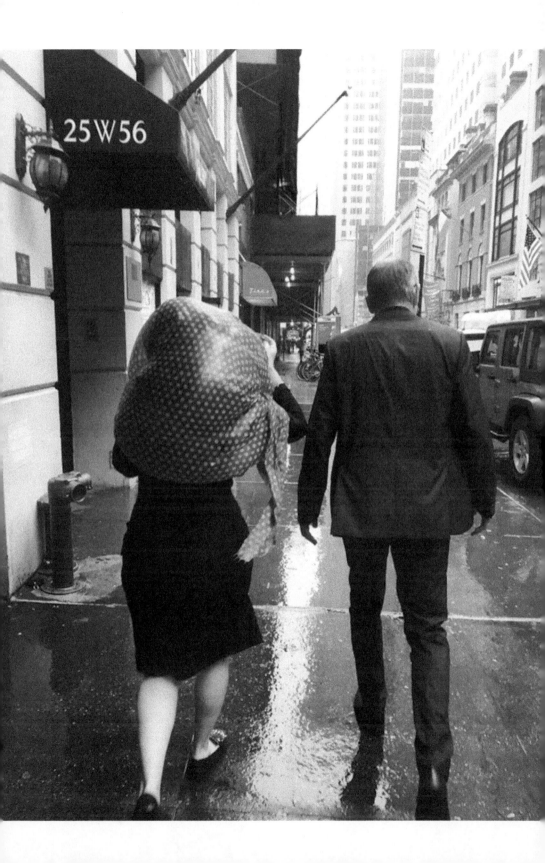

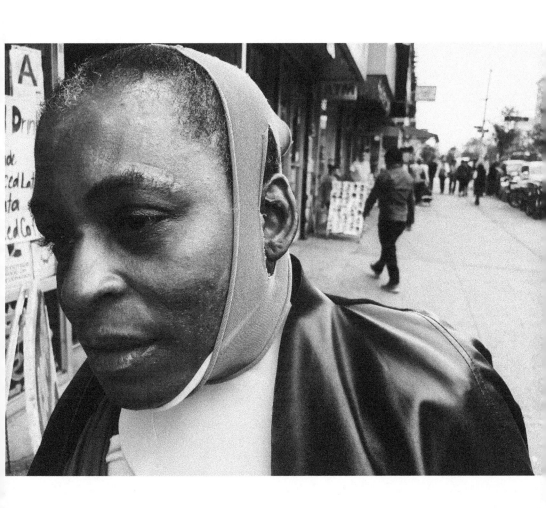

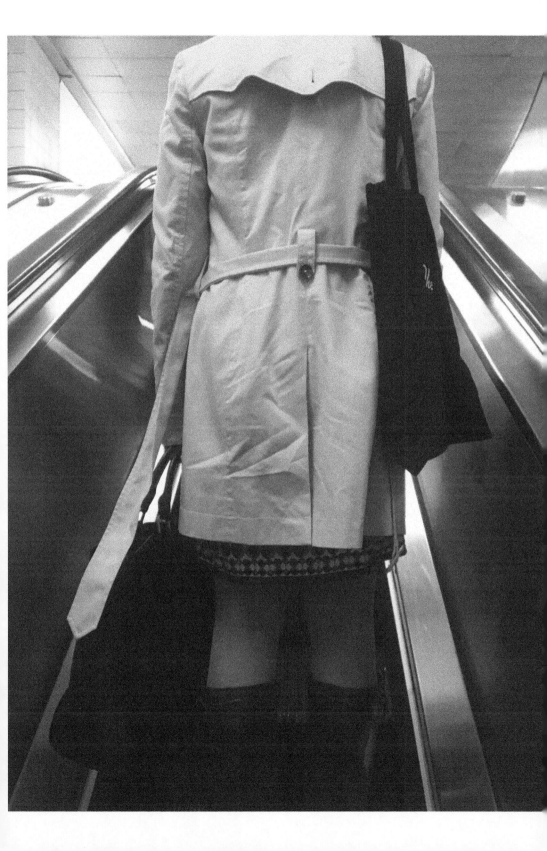

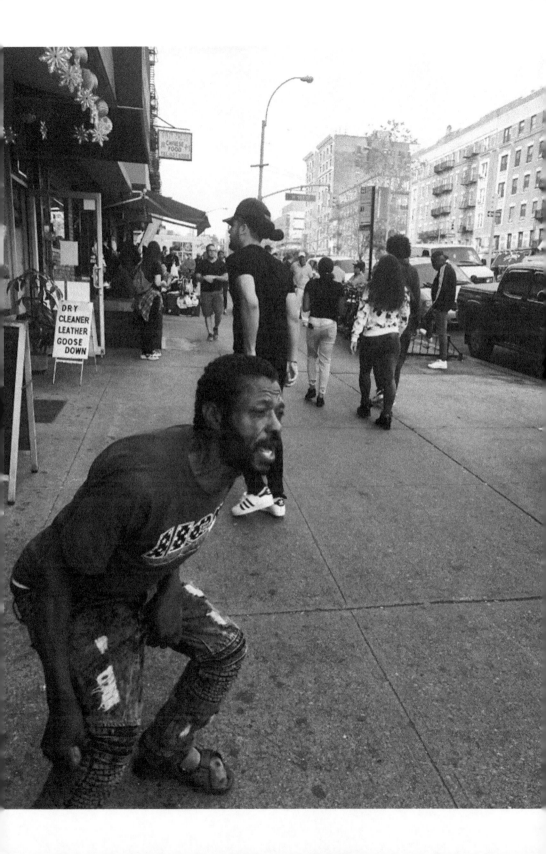

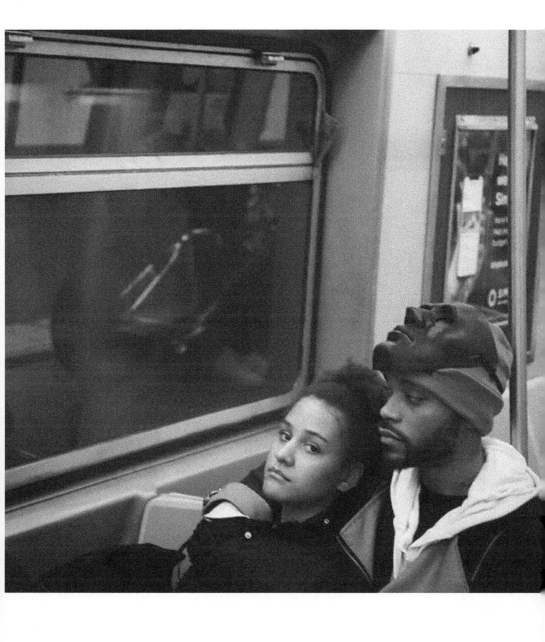

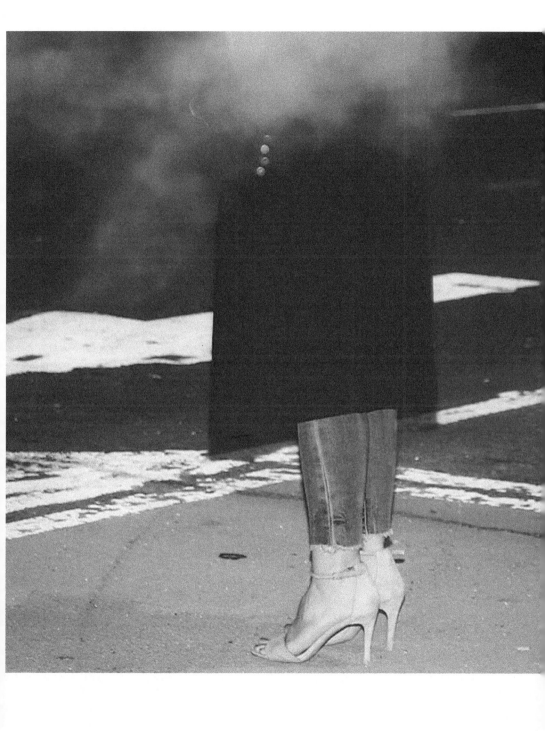

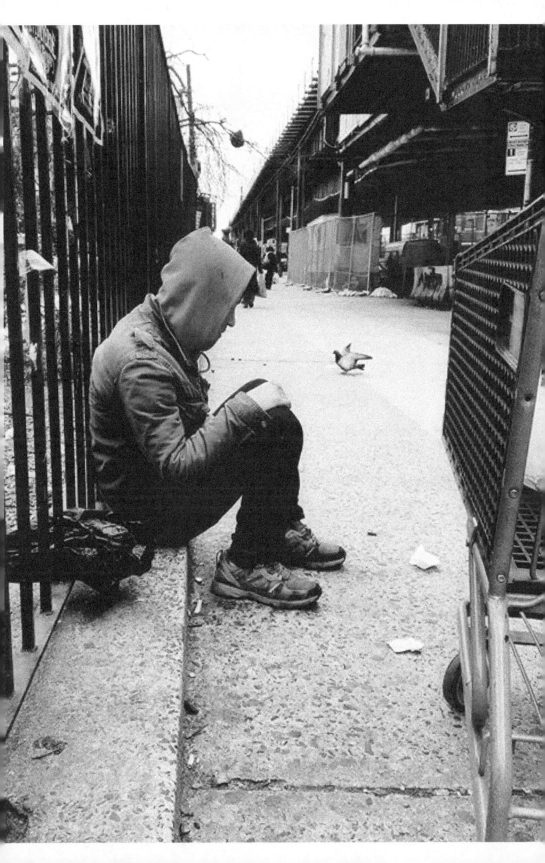

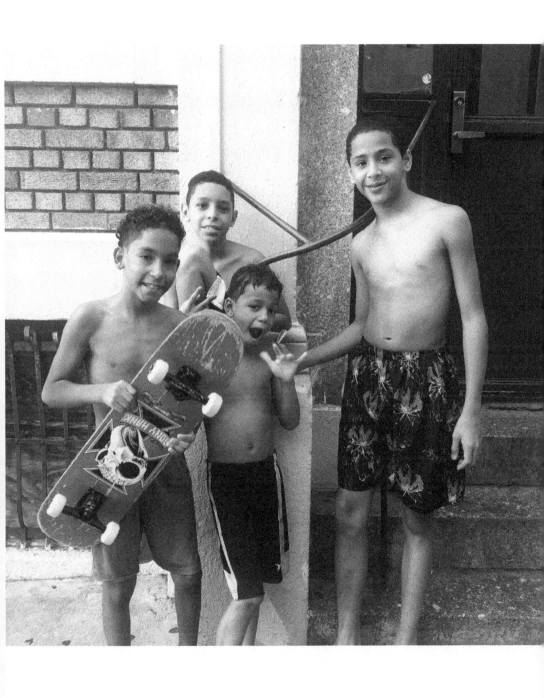

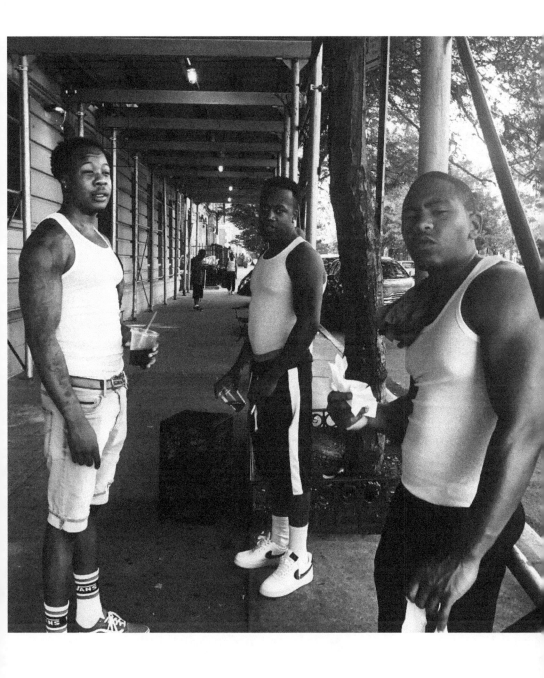

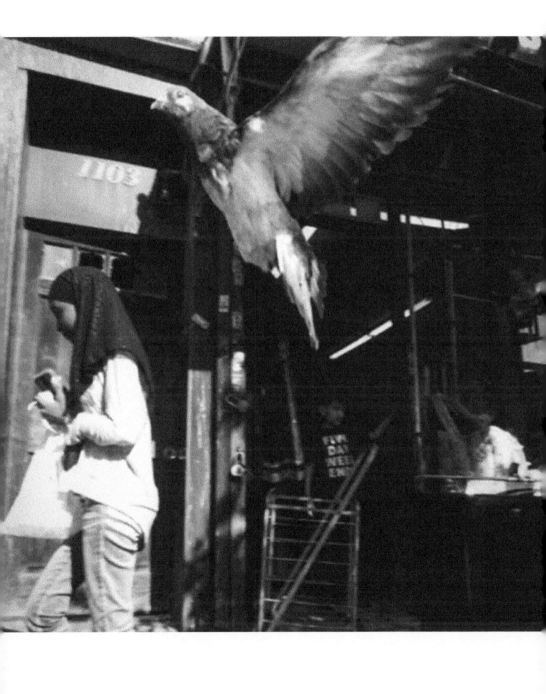

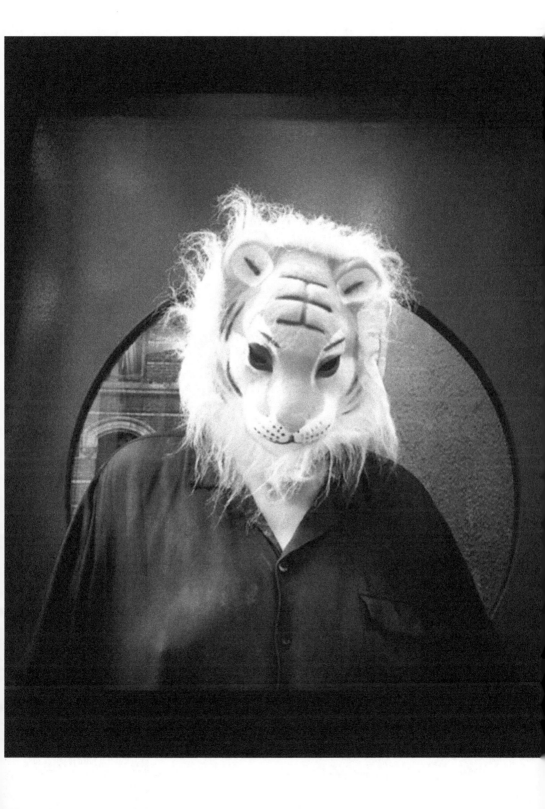

CPSIA information can be obtained
at www.ICGtesting.com
Printed in the USA
LVHW110201230719
624973LV00003B/5/P